MY RAD LIFE

A JOURNAL

MY RAD LIFE

A JOURNAL

WRITTEN BY
KATE SCHATZ

ILLUSTRATED BY
MIRIAM KLEIN STAHL

TEN SPEED PRESS
California | New York

WELCOME TO
MY RAD LIFE

Hi there! We are Kate and Miriam, the author and illustrator of the books *Rad American Women A-Z* and *Rad Women Worldwide*. Usually, we write about the lives of amazing women from around the world who have done all kinds of cool things. But this time, we decided to make a book about *you*, and your own radical, powerful, beautiful life.

Think of this journal as a place to get to know yourself better. It's filled with advice from some very cool women (who you can find out more about at the back of the journal), along with questions and prompts based on their wise words.

You can use this journal in any way you like. Start at the beginning and work your way to the end—or open it up to a random page and see what happens. Answer the questions and complete all the prompts—or fill the pages with doodles and drawings. Keep it in your backpack, your desk, your locker, your purse. Copy your favorite quotes onto sticky notes and stick them to your bedroom walls, or on the mirrors in the bathrooms at school (but, um, don't get in trouble). Try writing in this journal when you're bored instead of staring at your phone. Read one inspiring quote per day, or read them all at once at a Saturday night sleepover with your best friend. It's up to you: this is your book, and your radness.

What does it mean to be rad? It means awesome and cool, but it's more than that. When you're rad, you are strong, independent, and bold. You work to better yourself *and* the world. You stand and speak up for yourself, and for others. Now, let's be real here: it's not always easy to do and be all these things! No one acts and feels 100 percent rad 100 percent of the time! We're all works in progress, creating ourselves every day. That's the beauty of it all!

We hope that this journal can help you find ways to keep creating your own rad, wonderful self.

Love,
KATE + MIRIAM

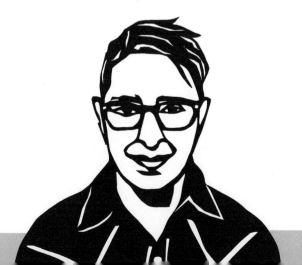

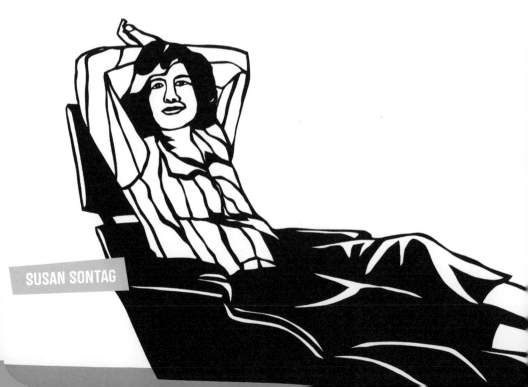
SUSAN SONTAG

"IN THE JOURNAL I DO NOT JUST EXPRESS MYSELF MORE OPENLY THAN I COULD TO ANY PERSON; I CREATE MYSELF."

"YOU MAY THINK I'M SMALL, BUT I HAVE A UNIVERSE INSIDE MY MIND."

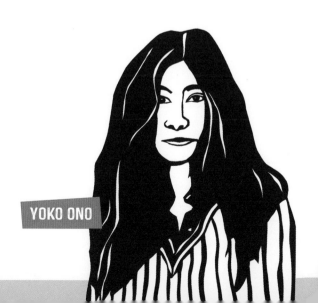
YOKO ONO

"THE TOOL OF EVERY SELF-PORTRAIT
IS THE MIRROR. YOU SEE YOURSELF
IN IT. TURN IT THE OTHER WAY,
AND YOU SEE THE WORLD."

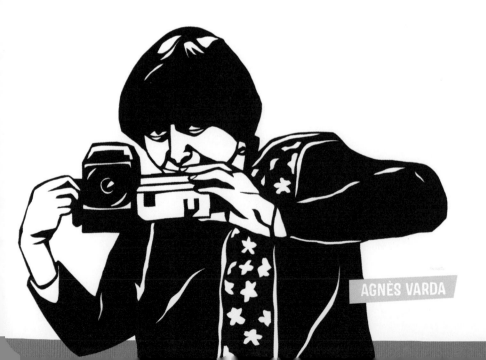

AGNÈS VARDA

 Look in the mirror and admire what you see. Then, create a self-portrait!

"I RUN MY WORLD."

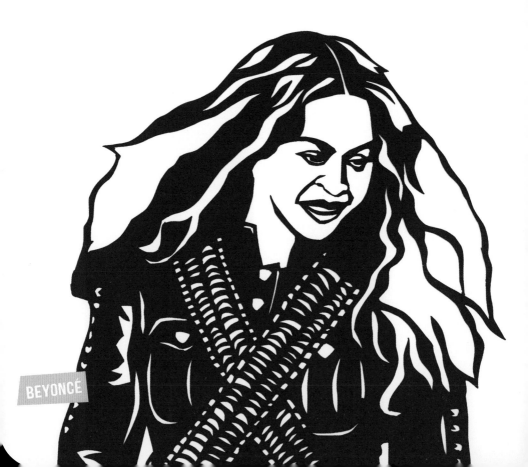

BEYONCÉ

"MY MOTHER TOLD ME TO BE
A LADY. AND FOR HER, THAT
MEANT BE YOUR OWN PERSON,
BE INDEPENDENT."

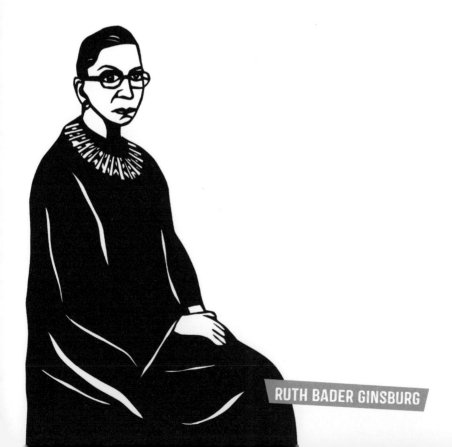

RUTH BADER GINSBURG

Justice Ginsburg's mom gave some good advice!
What kind of advice would you give your younger self?
What advice would you give to your future self?

"AN ACTIVIST IS SOMEONE WHO CANNOT HELP BUT FIGHT FOR SOMETHING. THAT PERSON IS NOT USUALLY MOTIVATED BY A NEED FOR POWER OR MONEY OR FAME, BUT IN FACT IS DRIVEN SLIGHTLY MAD BY SOME INJUSTICE, SOME CRUELTY, SOME UNFAIRNESS, SO MUCH SO THAT HE OR SHE IS COMPELLED BY SOME INTERNAL MORAL ENGINE TO ACT TO MAKE IT BETTER."

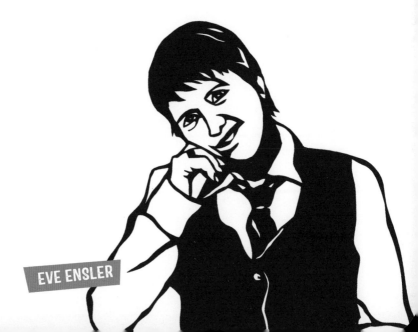
EVE ENSLER

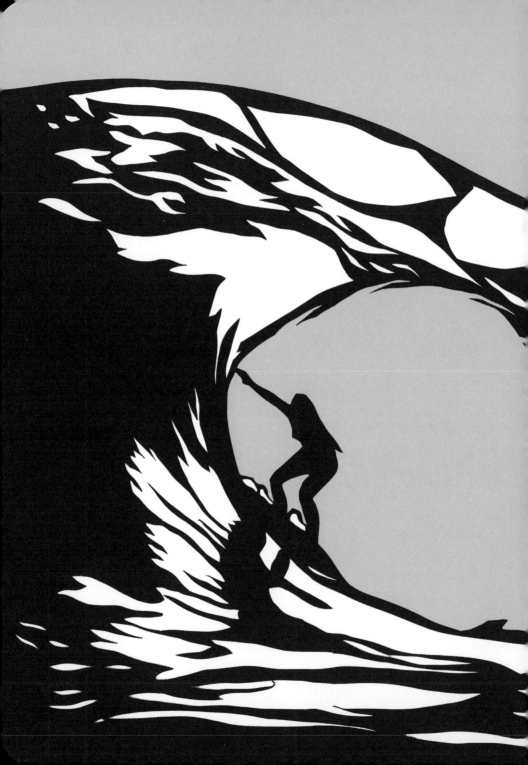

"THERE ARE SO MANY PEOPLE
OUT THERE WHO WILL TELL YOU
THAT YOU CAN'T. WHAT YOU'VE
GOT TO DO IS TURN AROUND
AND SAY 'WATCH ME.'"

LAYNE BEACHLEY

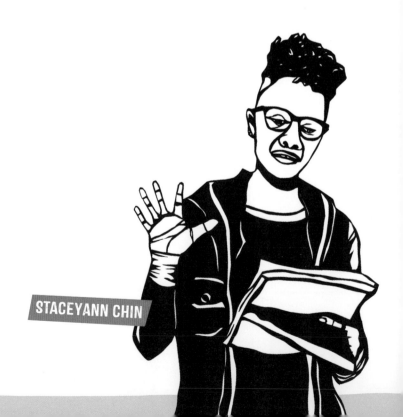

STACEYANN CHIN

"I AM A POEM IN PROGRESS; REMEMBER THAT THIS IS NOT THE FINAL COPY."

"WRITE TWO POEMS AND CALL ME IN THE MORNING. THAT'S MY PRESCRIPTION FOR YOU TODAY, WORLD, AND FOR ME."

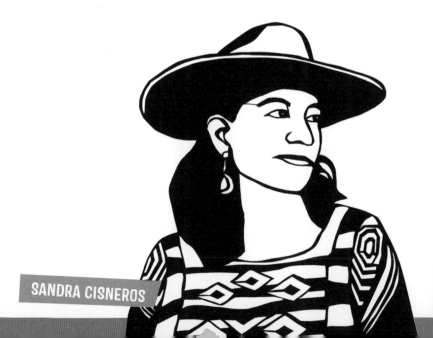

SANDRA CISNEROS

 Not feeling great today? Take author Sandra Cisneros's advice and write two poems . . .

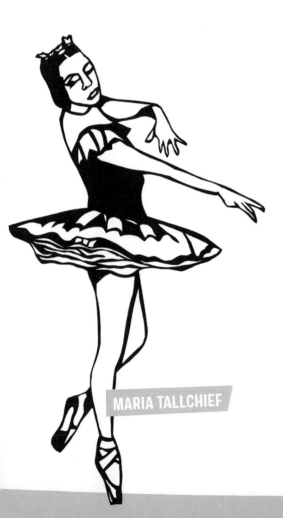

MARIA TALLCHIEF

"VERY OFTEN YOU ARE IN THE RIGHT PLACE,
AT THE RIGHT TIME, BUT YOU DON'T KNOW IT."

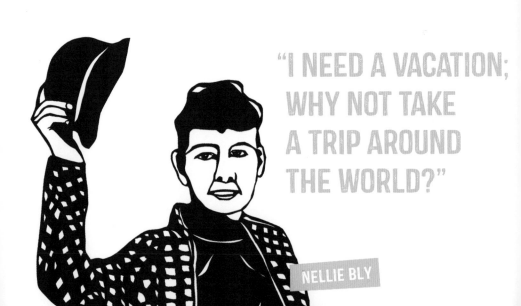

"I NEED A VACATION;
WHY NOT TAKE
A TRIP AROUND
THE WORLD?"

NELLIE BLY

Journalist and adventurer Nellie Bly famously traveled around the world in seventy-two days. Where in the world would YOU like to go? List all the places you'd like to visit!

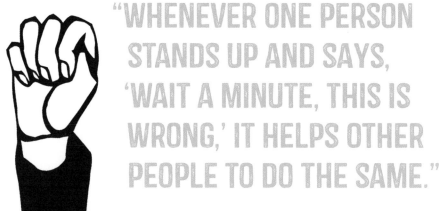

"WHENEVER ONE PERSON STANDS UP AND SAYS, 'WAIT A MINUTE, THIS IS WRONG,' IT HELPS OTHER PEOPLE TO DO THE SAME."

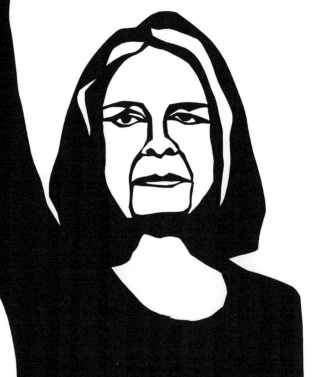

GLORIA STEINEM

 Think of a time when you stood up for someone or something. What did you say? How did it feel?

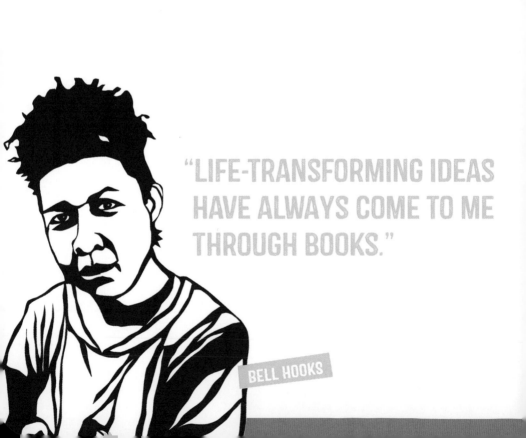

"LIFE-TRANSFORMING IDEAS HAVE ALWAYS COME TO ME THROUGH BOOKS."

BELL HOOKS

 What are your favorite books? Make a list! Draw the covers!

"WRITE YOUR OWN PART. IT'S THE ONLY WAY I'VE GOTTEN ANYWHERE."

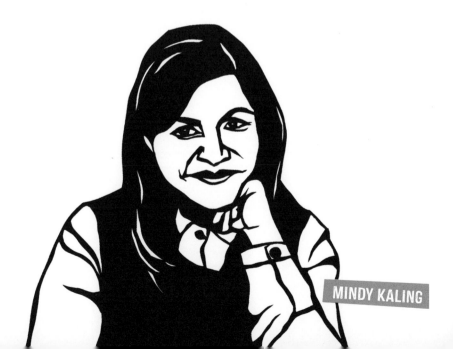

MINDY KALING

"WE DO NOT NEED MAGIC TO TRANSFORM OUR WORLD. WE CARRY ALL THE POWER WE NEED INSIDE OURSELVES ALREADY."

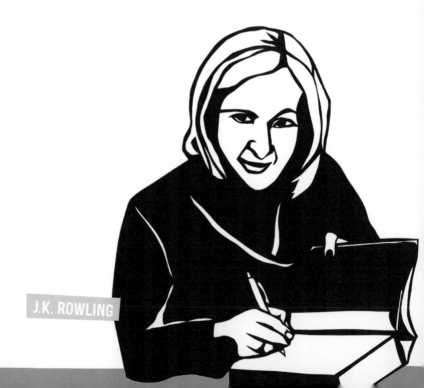

J.K. ROWLING

 J.K. Rowling was rejected by more than ten publishers before she found someone to publish her first book, *Harry Potter and the Sorcerer's Stone.* Imagine if she'd given up? Write about a time when you wanted to give up on something, but kept trying.

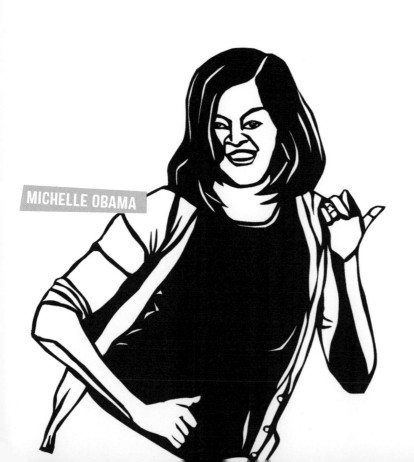

MICHELLE OBAMA

"YOU MAY NOT ALWAYS HAVE A COMFORTABLE LIFE AND YOU WILL NOT ALWAYS BE ABLE TO SOLVE ALL OF THE WORLD'S PROBLEMS AT ONCE. BUT DON'T EVER UNDERESTIMATE THE IMPORTANCE YOU CAN HAVE. HISTORY HAS SHOWN US THAT COURAGE CAN BE CONTAGIOUS AND HOPE CAN TAKE ON A LIFE OF ITS OWN."

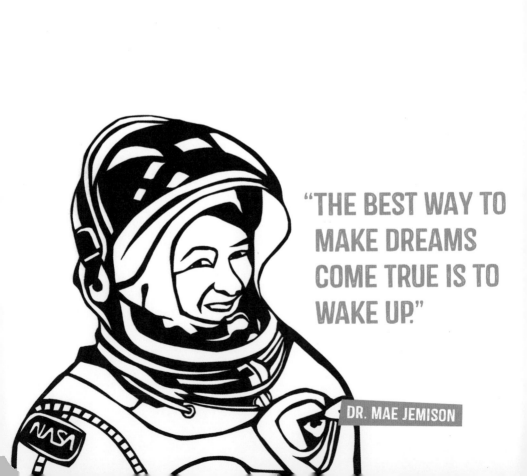

"THE BEST WAY TO MAKE DREAMS COME TRUE IS TO WAKE UP."

DR. MAE JEMISON

⭐ Make a list of your dreams.　　　⭐ How will you make them come true?

ADRIENNE RICH

"RESPONSIBILITY TO YOURSELF MEANS REFUSING TO LET OTHERS DO YOUR THINKING, TALKING, AND NAMING FOR YOU; IT MEANS LEARNING TO RESPECT AND USE YOUR OWN BRAINS AND INSTINCTS."

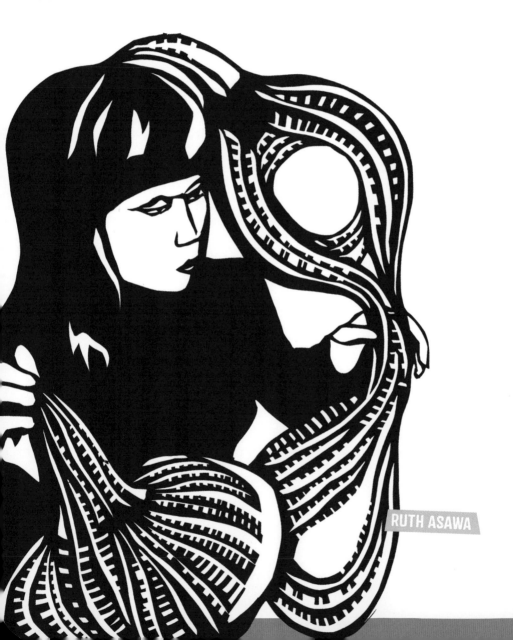

"THE BEST IDEAS COME UNEXPECTEDLY FROM A CONVERSATION OR A COMMON ACTIVITY LIKE WATERING THE GARDEN. THESE CAN GET LOST OR SLIP AWAY IF NOT ACTED ON WHEN THEY OCCUR."

RUTH ASAWA

 Artist Ruth Asawa often drew inspiration from the world around her. Save this page for the moment when inspiration strikes unexpectedly!

"AS LONG AS YOU SAY THERE IS NO HOPE, THEN THERE WILL BE NO HOPE."

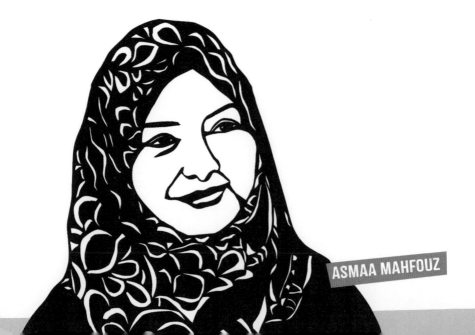

ASMAA MAHFOUZ

"NO PERSON IS
YOUR FRIEND
WHO DEMANDS
YOUR SILENCE,
OR DENIES YOUR
RIGHT TO GROW."

ALICE WALKER

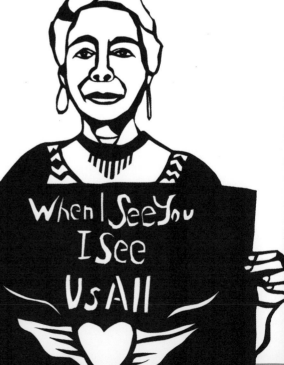

 Who are your best friends and what do you love about them?

"I DON'T WANT OTHER PEOPLE TO DECIDE WHO I AM. I WANT TO DECIDE THAT FOR MYSELF."

EMMA WATSON

"YOU WERE BORN TO BE REAL,
NOT TO BE PERFECT."

LILLY SINGH

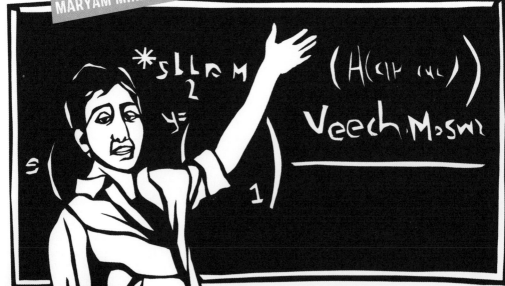

MARYAM MIRZAKHANI

"IT'S NOT ONLY THE QUESTION,
BUT THE WAY YOU TRY TO SOLVE IT."

"WHAT I TREASURE MOST IN LIFE IS BEING ABLE TO DREAM. DURING MY MOST DIFFICULT MOMENTS AND COMPLEX SITUATIONS, I HAVE BEEN ABLE TO DREAM OF A MORE BEAUTIFUL FUTURE."

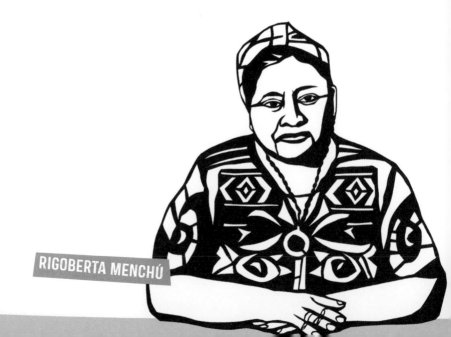

RIGOBERTA MENCHÚ

 What does your beautiful future look like?

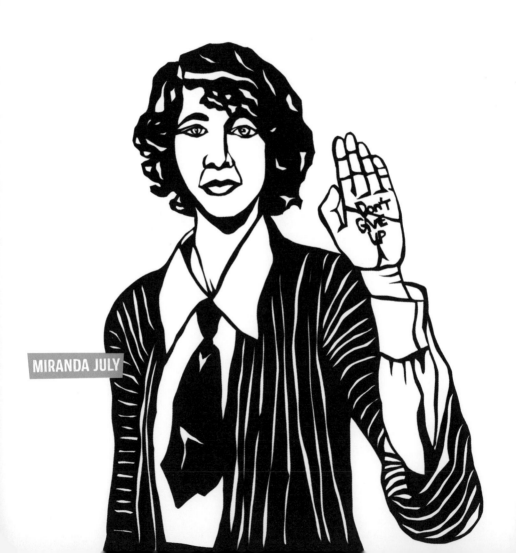

MIRANDA JULY

"LOOK AT THE SKY: THAT IS FOR YOU. LOOK AT EACH PERSON'S FACE AS YOU PASS THEM ON THE STREET: THOSE FACES ARE FOR YOU. AND THE STREET ITSELF, AND THE GROUND UNDER THE STREET, AND THE BALL OF FIRE UNDERNEATH THE GROUND: ALL THESE THINGS ARE FOR YOU. THEY ARE AS MUCH FOR YOU AS THEY ARE FOR OTHER PEOPLE. REMEMBER THIS WHEN YOU WAKE UP IN THE MORNING AND THINK YOU HAVE NOTHING."

"NO MATTER WHAT YOUR DIFFERENCES ARE, YOU HAVE TO EMBRACE THEM AND BE PROUD OF THE WAY YOU ARE."

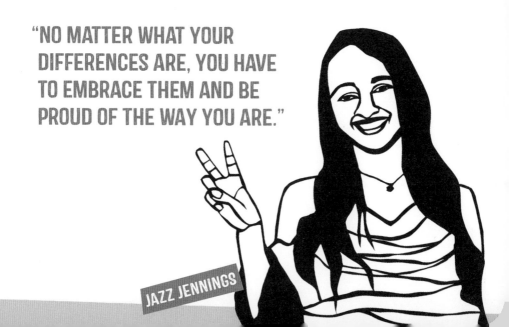

JAZZ JENNINGS

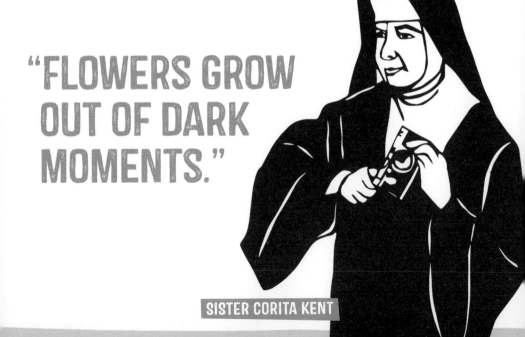

"FLOWERS GROW
OUT OF DARK
MOMENTS."

SISTER CORITA KENT

 Use this page when you're having a dark moment. Fill it with flowers of any size, of any color. Can you make it bloom?

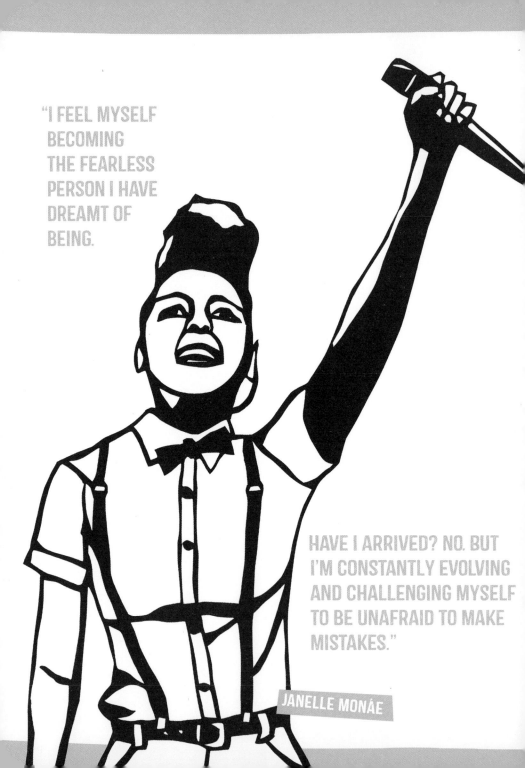

"I FEEL MYSELF BECOMING THE FEARLESS PERSON I HAVE DREAMT OF BEING.

HAVE I ARRIVED? NO. BUT I'M CONSTANTLY EVOLVING AND CHALLENGING MYSELF TO BE UNAFRAID TO MAKE MISTAKES."

JANELLE MONÁE

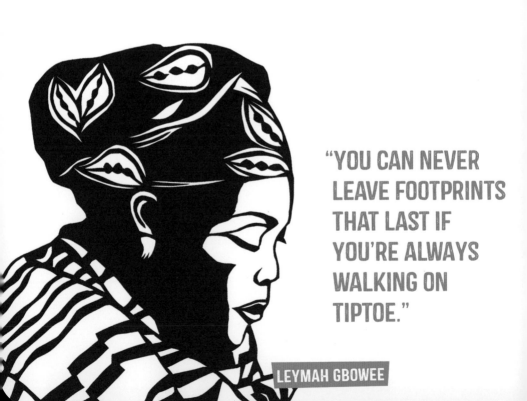

"YOU CAN NEVER LEAVE FOOTPRINTS THAT LAST IF YOU'RE ALWAYS WALKING ON TIPTOE."

LEYMAH GBOWEE

"IN ART AND DREAM MAY YOU PROCEED WITH ABANDON."

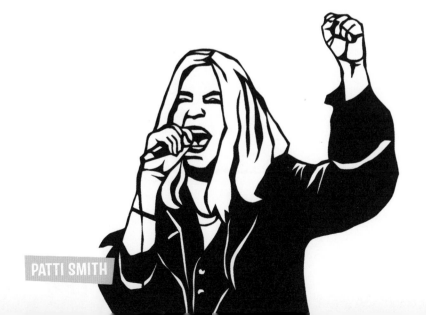

PATTI SMITH

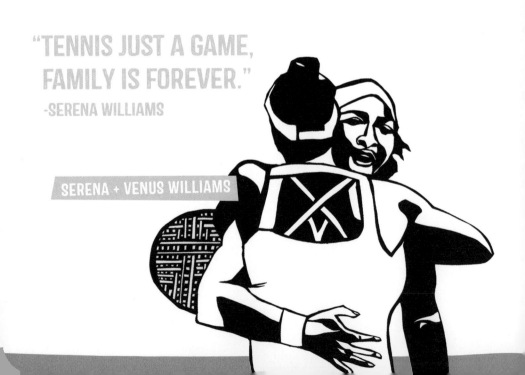

"TENNIS JUST A GAME,
FAMILY IS FOREVER."
-SERENA WILLIAMS

SERENA + VENUS WILLIAMS

 Describe your family. What are they like?
What do you do to support each other?

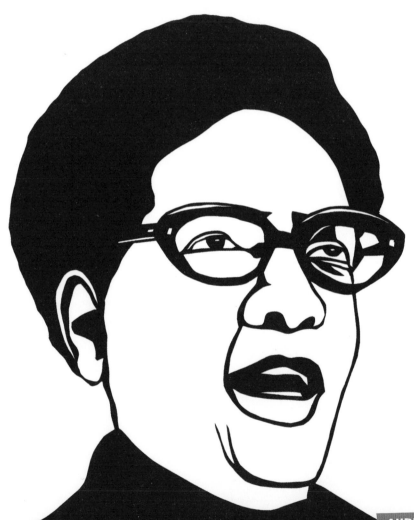

AUDRE LORDE

"WHEN I DARE TO BE POWERFUL, TO USE MY STRENGTH IN THE SERVICE OF MY VISION, THEN IT BECOMES LESS AND LESS IMPORTANT WHETHER I AM AFRAID."

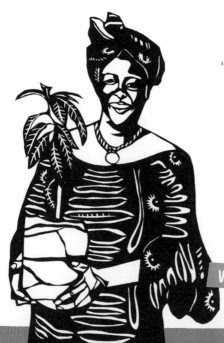

"YOU CANNOT PROTECT THE ENVIRONMENT UNLESS YOU EMPOWER PEOPLE, YOU INFORM THEM, AND YOU HELP THEM UNDERSTAND THAT THESE RESOURCES ARE THEIR OWN, THAT THEY MUST PROTECT THEM."

WANGARI MAATHAI

 What environment do you live in? Whether you live in a big city or a small town, there are plants and animals nearby. Take a walk outside and pay close attention to all the plants and animals (weeds and bugs included!) in your neighborhood. Then document them here!

"NO MATTER HOW HARD THEY
GO AFTER ME, I NEVER GIVE UP."

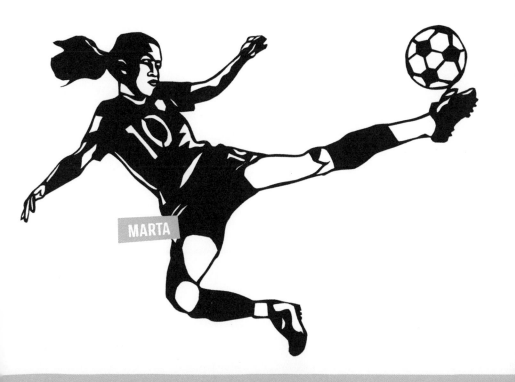
MARTA

"KNOW HOW TO LEARN. THEN, WANT TO LEARN."

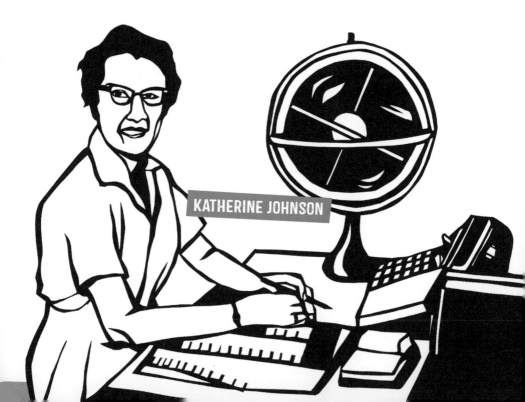

KATHERINE JOHNSON

 When mathematician and space scientist Katherine Johnson was a kid, she loved math so much that she would count everything she saw. What are you fascinated by? Make a list of all the things you'd like to learn about!

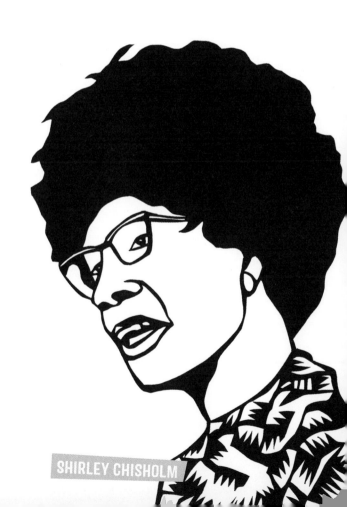

"I AM AND ALWAYS WILL BE A CATALYST FOR CHANGE."

SHIRLEY CHISHOLM

"DO NOT ALLOW PEOPLE TO DIM
YOUR SHINE BECAUSE THEY
ARE BLINDED. TELL THEM
TO PUT ON SOME SUNGLASSES!"

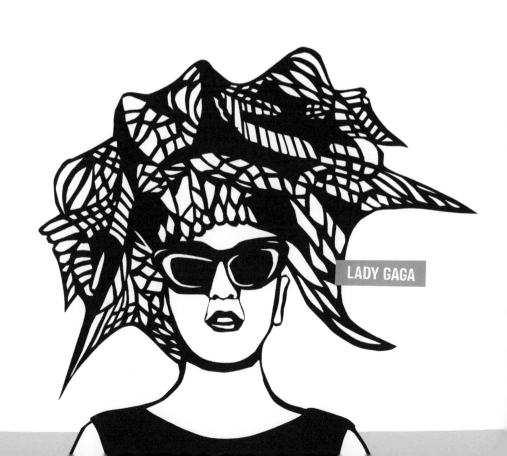

LADY GAGA

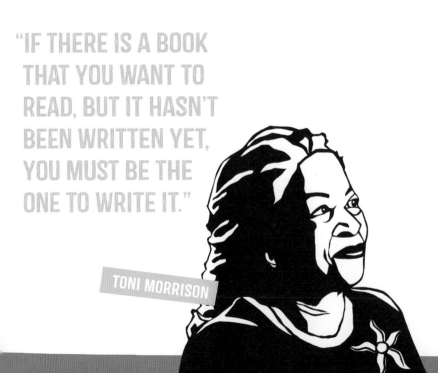

"IF THERE IS A BOOK THAT YOU WANT TO READ, BUT IT HASN'T BEEN WRITTEN YET, YOU MUST BE THE ONE TO WRITE IT."

TONI MORRISON

 Do you have a bunch of rad story ideas? Are you plotting a novel in your head? Write your book ideas here! Or, go ahead and just start writing . . .

"LOVE IS THE BIG BOOMING BEAT WHICH COVERS UP THE NOISE OF HATE."

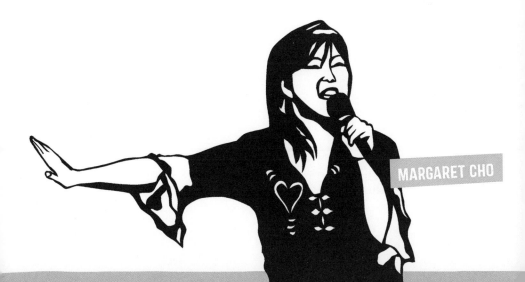
MARGARET CHO

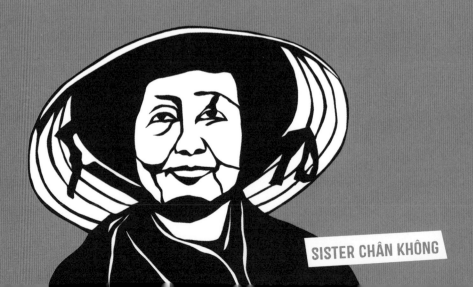

"SOMETIMES I FEEL OVERWHELMED. BUT I TRY TO WORK ONE DAY AT A TIME. IF WE JUST WORRY ABOUT THE BIG PICTURE, WE ARE POWERLESS. SO MY SECRET IS TO START RIGHT AWAY DOING WHATEVER LITTLE WORK I CAN DO."

SISTER CHÂN KHÔNG

 What do you do when you get overwhelmed?
What helps you calm down and feel better?

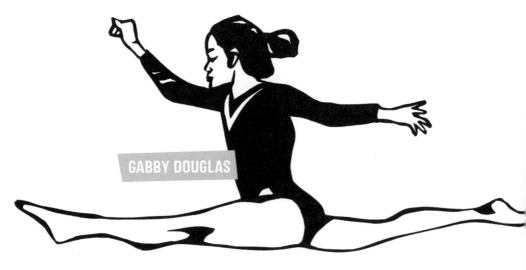

GABBY DOUGLAS

"I KIND OF DO THINK OF
MYSELF AS A SUPERHERO . . . "

 What kind of superhero would you be? What are your superpowers? What would your superhero costume look like? Is there a cape?!

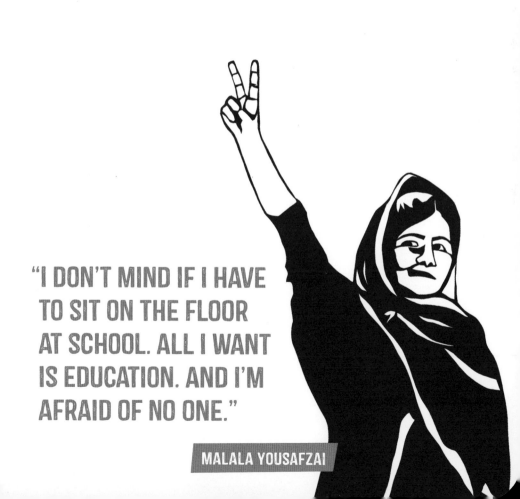

"I DON'T MIND IF I HAVE TO SIT ON THE FLOOR AT SCHOOL. ALL I WANT IS EDUCATION. AND I'M AFRAID OF NO ONE."

MALALA YOUSAFZAI

"THE MOST IMPORTANT THING YOU WEAR IS YOUR PERSONALITY."

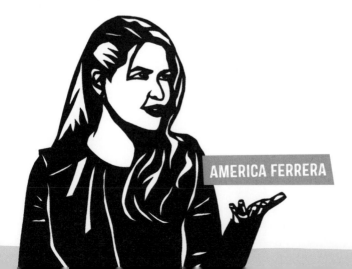

AMERICA FERRERA

 What do you like to wear when you're feeling silly? Sad? Cozy? What do you wear to help you feel confident and powerful?

"WE CAN BEGIN BY DOING SMALL THINGS AT THE LOCAL LEVEL, LIKE PLANTING COMMUNITY GARDENS OR LOOKING OUT FOR OUR NEIGHBORS. THAT IS HOW CHANGE TAKES PLACE IN LIVING SYSTEMS, NOT FROM ABOVE BUT FROM WITHIN, FROM MANY LOCAL ACTIONS OCCURRING SIMULTANEOUSLY."

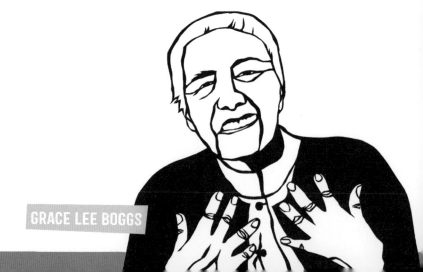

GRACE LEE BOGGS

 What are some actions that you can take in your local community—on your block, in your school, in your home—to make positive change?

"TO LOVE. TO BE LOVED. TO NEVER FORGET YOUR OWN INSIGNIFICANCE . . . TO SEEK JOY IN THE SADDEST PLACES . . . TO NEVER SIMPLIFY WHAT IS COMPLICATED OR COMPLICATE WHAT IS SIMPLE. TO RESPECT STRENGTH, NEVER POWER. ABOVE ALL, TO WATCH. TO TRY AND UNDERSTAND. TO NEVER LOOK AWAY. AND NEVER, NEVER TO FORGET."

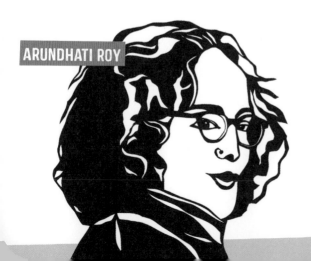

ARUNDHATI ROY

ABOUT
KATE + MIRIAM

KATE SCHATZ + MIRIAM KLEIN STAHL ARE THE AUTHOR AND ILLUSTRATOR OF THE BOOKS *RAD AMERICAN WOMEN A-Z* AND *RAD WOMEN WORLDWIDE*. THEY ARE BOTH ARTISTS, EDUCATORS, AND PARENTS WHO LIVE IN CALIFORNIA, AND WHO DREAM OF AND WORK TOWARD A RAD, JUST, AND FEMINIST FUTURE FOR ALL.

ABOUT THE RAD WOMEN IN THIS JOURNAL

RUTH ASAWA (1926–2013) was a Japanese-American sculptor who created abstract wire sculptures. She learned to draw as a child, when her family was held in an internment camp during World War II.

LAYNE BEACHLEY (1972–) became a pro surfer at age sixteen and is the first woman to win seven surfing World Championships.

BEYONCÉ (1981–) is an internationally known singer, songwriter, performer, and activist, and one of the bestselling music artists of all time.

NELLIE BLY (1864–1922) was an investigative journalist and adventurer who set a world record by traveling around the world in seventy-two days, in 1888.

GRACE LEE BOGGS (1915–2015) was an author, philosopher, and activist who spent seven decades committed to community organizing and social justice.

STACEYANN CHIN (1972–) is a poet, spoken word performer, and LGBTQ activist who uses her art to speak out against injustice, and to explore her identity as a queer Chinese-Jamaican-American woman.

SHIRLEY CHISHOLM (1924–2005) was the first African-American woman elected to the U.S. Congress, the first major-party African-American candidate for President of the United States, and the first woman ever to run for the Democratic Party's presidential nomination.

MARGARET CHO (1968–) is a Grammy- and Emmy-nominated comedian, performer, and singer-songwriter. She is a long-time activist who works on behalf of the LGBTQ community.

SANDRA CISNEROS (1954–) is the first female Mexican-American writer to have her work published by a mainstream American publisher.

GABBY DOUGLAS (1995–) is a world champion gymnast and the first African-American woman in Olympic history to become the individual all-around champion.

EVE ENSLER (1953–) is a feminist playwright, activist, and author best known for her play *The Vagina Monologues*. She is the founder of V-Day, an international movement to end violence against women and girls.

AMERICA FERRERA (1984–) is an award-winning actor and political activist, and the daughter of Honduran immigrants.

LADY GAGA (1986–) is a singer, songwriter, and performer known for her innovative costumes and dance music, as well as her work on behalf of LGBTQ youth.

LEYMAH GBOWEE (1972–) is a Nobel Peace Prize–winning activist who started a women's peace movement in her war-torn country of Liberia.

RUTH BADER GINSBURG (1933–) is the second female Supreme Court justice in American history, and has spent her life as an advocate for women's rights.

BELL HOOKS (1952–) is an influential feminist writer, thinker, and scholar who has published many articles and more than 30 books exploring the connections between race, gender, class, and power.

DR. MAE JEMISON (1956–) is a physicist, a dancer, a professor, and an entrepreneur. As a NASA astronaut, she was also the first African-American woman in space.

JAZZ JENNINGS (2000–) is a transgender teenage author and activist. As the youngest person to become a national transgender spokesperson, Jazz has inspired and empowered many other trans youth.

KATHERINE JOHNSON (1918–) is a mathematician and physicist who worked for NASA and calculated the trajectories for the space flights of John Glenn, the first American to orbit earth, and Apollo 11, the first human mission to the moon.

MIRANDA JULY (1974–) is an artist, writer, and filmmaker who has been making art on her own terms since she was a teenager.

MINDY KALING (1979–) is an actor, comedian, writer, and producer. She started writing for *The Office* when she was 24, and is the creator, writer, and star of *The Mindy Project*. She is one of the few Indian-American women on American TV.

SISTER CORITA KENT (1918–1986) was a nun, an artist, a teacher, and an activist who specialized in graphic design and screen printing. She used her role as an artist and teacher to speak out against the Vietnam War and other humanitarian crises.

SISTER CHÂN KHÔNG (1938–) is a Buddhist Zen master from Vietnam who has worked as a humanitarian for many years, training people to be peace workers, helping rebuild war-torn villages, and teaching meditation and mindfulness practices.

AUDRE LORDE (1934–1992) was a poet, activist, feminist, and writer who published over fifteen books that addressed civil rights, feminism, and the exploration of black female identity.

WANGARI MAATHAI (1940–2011) was the first African woman to win the Nobel Peace Prize. Her work as an environmental activist and leader in Kenya led to The Green Belt movement, which has empowered thousands of women and planted over fifty-one million trees in Kenya alone.

ASMAA MAHFOUZ (1985–) is a young Egyptian activist and leader who helped spark a mass uprising in Egypt by posting videos on her popular blog encouraging people to take to the streets to demand change.

MARTA (1986–) is considered the greatest female soccer player in the world. In addition to her work on the soccer field, Marta is a goodwill ambassador for the United Nations, and speaks regularly about ending violence against women.

RIGOBERTA MENCHÚ (1959–) has dedicated her life to advocating for the rights of indigenous communities, both in her own country of Guatemala and around the world. She won the Nobel Peace Prize in 1992.

MARYAM MIRZAKHANI (1977–) is a mathematician who became the first woman and first Iranian to be awarded the Fields Medal, the most prestigious prize in mathematics.

JANELLE MONÁE (1985–) is a singer, performer, producer, and social activist whose music blends science fiction, politics, and humor with pop and R&B.

TONI MORRISON (1931–) is a writer who has published eleven novels and won the Pulitzer Prize, the Nobel Prize, the American Book Award, and a Presidential Medal of Freedom.

MICHELLE OBAMA (1964–) is a lawyer and a writer who served as the First Lady of the United States from 2008-2017. She is married to Barack Obama, the 44th U.S. President.

YOKO ONO (1933–) is a Japanese artist, musician, and peace activist who has been making art and speaking out against war for over fifty years.

ADRIENNE RICH (1929–2012) was a poet, essayist, and feminist who was considered one of the most widely read and influential poets and intellectuals of the 20th century.

J.K. ROWLING (1965–) is the author of the best-selling book series of all time: Harry Potter. Her publisher suggested she use the initials "J.K." instead of "Joanna" because he worried that boys wouldn't read books written by a woman.

ARUNDHATI ROY (1961–) is an Indian writer who writes fearlessly and extensively about human rights and global politics.

LILLY SINGH (1988–), better known as ||Superwoman||, is a Canadian Youtube personality, vlogger, comedian, and rapper whose Youtube channel has over 1 billion views. She uses her platform to share her experiences as a South Asian woman.

PATTI SMITH (1946–) is a singer, songwriter, poet, and artist who is considered by many to be the "punk poet laureate" or the "godmother of punk."

SUSAN SONTAG (1933–2004) was one of America's leading thinkers, cultural critics, activists, and writers. She wrote about everything from photography to human rights to AIDS and inspired generations of writers.

GLORIA STEINEM (1934–) is an American feminist, journalist, and social and political activist, who is a prominent figure and a spokeswoman for women worldwide.

MARIA TALLCHIEF (1925–2013) was a Native American ballet dancer who became the first major American prima ballerina.

AGNÈS VARDA (1928–) is a French film director who was a central figure in the famous French New Wave cinema movement.

ALICE WALKER (1944–) is a novelist, poet, and civil rights activist whose most famous book, *The Color Purple*, has been made into a film and a Broadway musical.

EMMA WATSON (1990–) is a British actor who is best known for her role as Hermione in the Harry Potter movies. She is also an outspoken feminist activist and the public face of the United Nation's "HeForShe" campaign that calls for men to stand up for women's rights.

VENUS + SERENA WILLIAMS (1980– and 1981–), also known as "the Williams sisters" are two of the top tennis players in the world. Venus is a seven-time Grand Slam title winner, and Serena is a twenty-three-time Grand Slam title winner. They have both won four Olympic gold medals.

MALALA YOUSAFZAI (1997–) received the Nobel Peace Prize for her brave fight for education in the face of violence. At seventeen, she was the youngest person ever to win the Nobel Prize, and the first Pakistani person as well.

Text copyright © 2017 by Kate Schatz
Illustrations copyright © 2016, 2017 by Miriam Klein Stahl

Published in the United States by Ten Speed Press, an imprint of
the Crown Publishing Group, a division of Penguin Random House LLC,
New York.
www.crownpublishing.com
www.tenspeed.com

Ten Speed Press and the Ten Speed Press colophon are registered
trademarks of Penguin Random House LLC.

Based on the book *Rad Women Worldwide* written by Kate Schatz
and illustrated by Miriam Klein Stahl, published by Ten Speed Press,
Berkeley, in 2016.

Some of the illustrations in this journal were originally published
in *Rad Women Worldwide*.

Library of Congress Cataloging-in-Publication Data is on file with the publisher.

Trade Paperback ISBN: 978-0-399-57950-9

Printed in China

Design by Lizzie Allen

10 9 8 7 6 5 4 3 2 1

First Edition